hey! you can do it

About the Artist

hello

Selfie Time! Draw a mini portrait of yourself. Don't stress - relax & have fun with it!

Name & Birthday

Relax, Have FUN & Be Creative!

7 of your FAVORITES! Write one in each petal!

- Favorite Show
- Favorite Food
- Favorite Quote
- Favorite Color
- Favorite Celebrity
- Favorite Song
- Favorite Animal

3 FUN Facts about YOU!

Fact #1

Fact #2

Fact #3

DRAWING USING LINES

Definition: Drawing with the use of Lines is a fundamental artistic technique where artists create images primarily through the use of lines rather than relying on shading, color, or other techniques. Lines can vary in thickness, length, and direction to convey different elements and emotions within a drawing.

Applications where Line Drawings are Used:

Illustration: Used in creating illustrations and designs where line work is the primary focus.

Figure Drawing: Essential for constructing figures and anatomical studies, using lines to define shapes and proportions.

Architectural Drawing: Used to create detailed architectural plans and elevations.

Comics and Animation: Fundamental in comic art and animation for defining characters, actions, and scenes.

Making Straight Lines

Without the use of a ruler, make horizontal lines by connecting the dots.

Without the use of a ruler, make vertical lines by connecting the dots.

Without the use of a ruler, connect the dots to make an X.

Making Straight Lines

Without the use of a ruler, connect the dots to make triangles.

Making Straight Lines

Without the use of a ruler, connect the dots to make slanted lines..

BEARS BEHIND BARS

Can you put the bears behind bars by tracing the lines and drawing new ones?

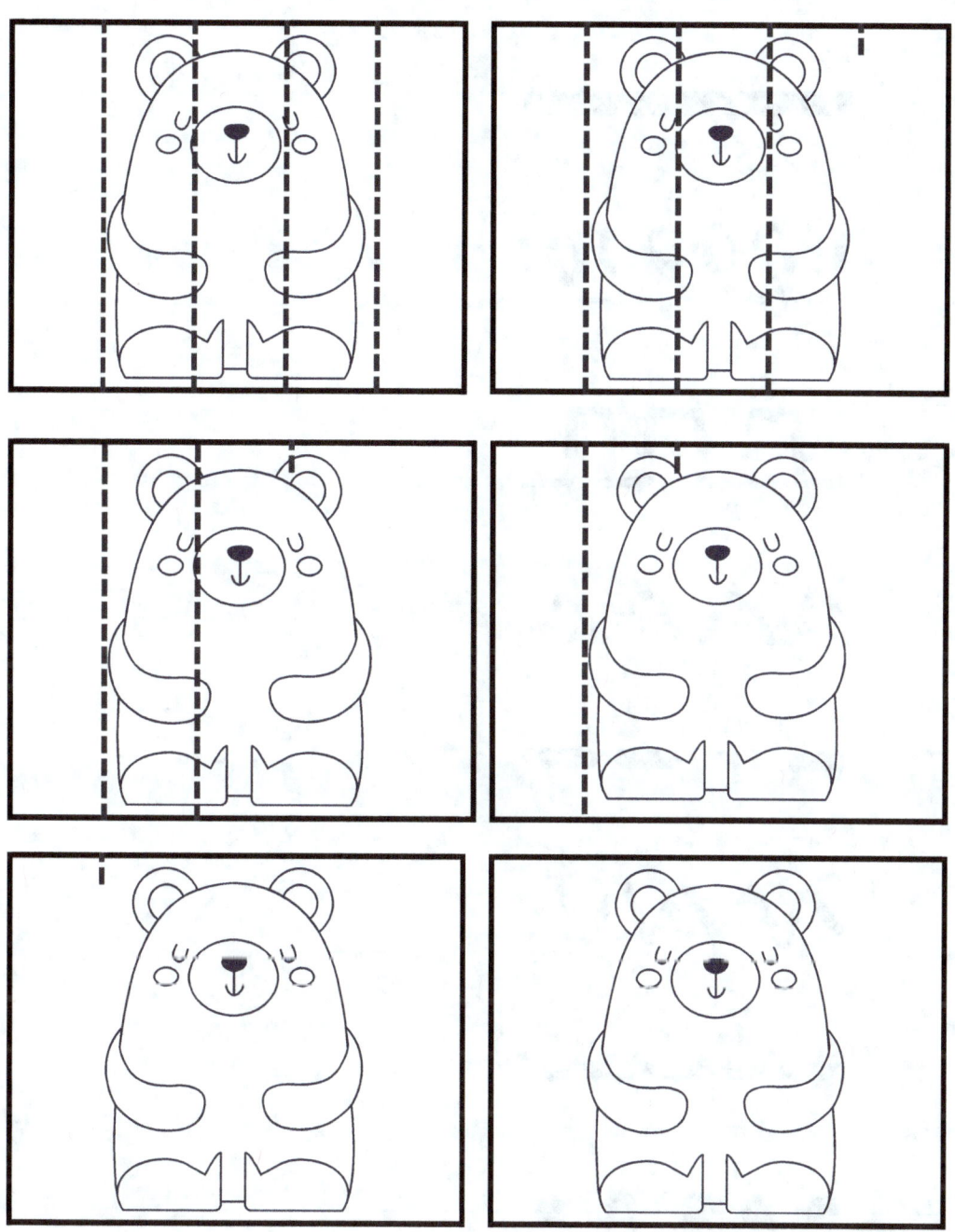

Finish *the* Lines

Draw the following items to the space provided.

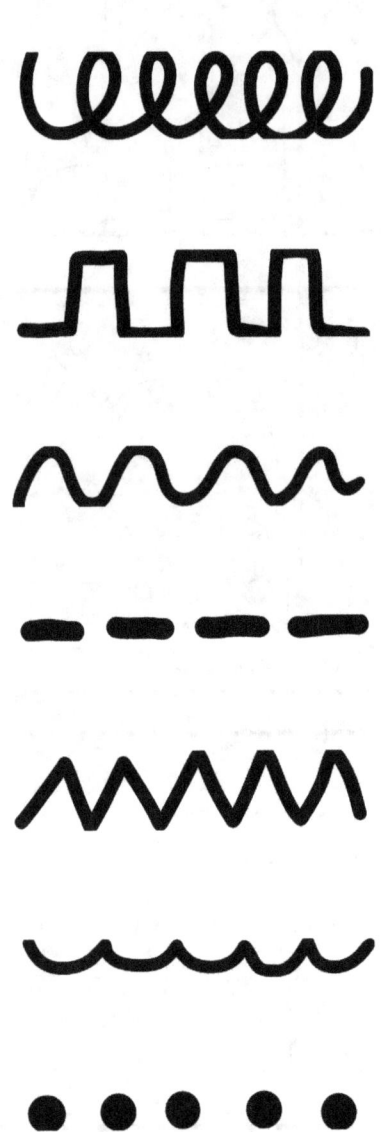

Grouped Lines

Draw the following items to the space provided.

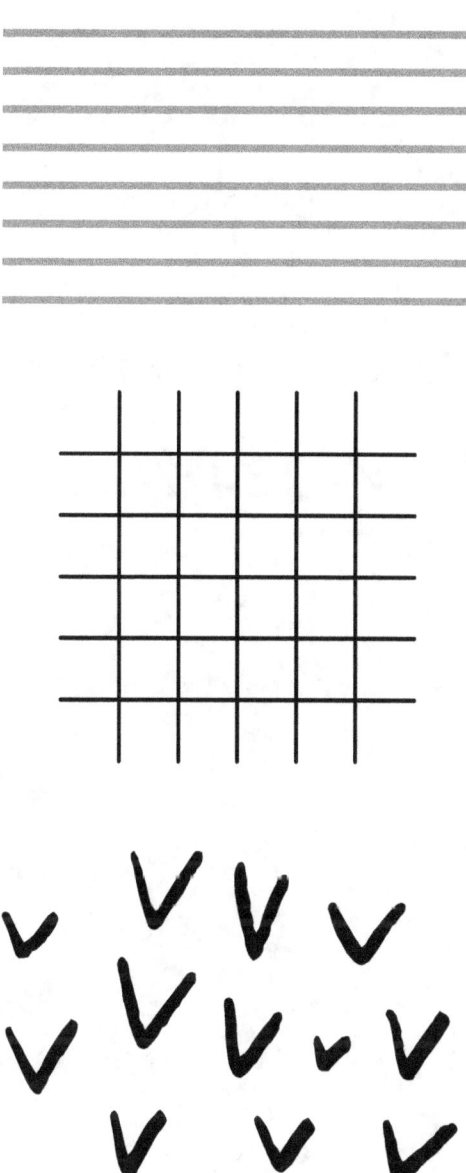

Curved Lines

Draw the following lines to the space provided.

Draw Shapes

Complete the rectangles by connecting the broken lines.

Complete the squares by connecting the broken lines.

Complete the triangles by connecting the broken lines.

Complete the circles by connecting the broken lines.

Let's Draw Flowers

1. Make flower stems.

2. Draw flowers on the stems below.

Let's Draw Lollipop Sticks

1. Make lollipop sticks.

2. Draw lollipops on the stick below.

Let's Draw Kites

1. Make kite strings.

2. Draw kites on the strings below.

Let's Draw Balloons

1. Make balloon strings.

2. Draw balloons on the strings below.

Make Faces

Use different kinds of lines to draw characters!

DIRECTED DRAWING

Definition: Directed Drawing is an instructional technique where there are guided steps to complete a given drawing. Each step builds on the previous one, allowing learners to gradually develop their skills and understand the process of creating a drawing from start to finish.

Goals of Directed Drawing

Skill Development: To help learners improve fundamental drawing skills such as line control, proportion and perspective by focusing on one step at a time.

Encourage Attention to Detail: To teach students how to observe and replicate details accurately, enhancing their ability to capture nuances and intricacies in their work.

Promote Creativity: While directed drawing provides specific instructions, it also encourages creativity by allowing students to apply the techniques learned to create their unique versions of the guided drawing.

Provide Structure: To offer a structured learning experience that can be particularly beneficial for young learners or beginners, helping them grasp the basics of drawing before moving on to more complex concepts.

Build Confidence: To offer support that can boost confidence especially for beginners who may feel overwhelmed by open-ended tasks.

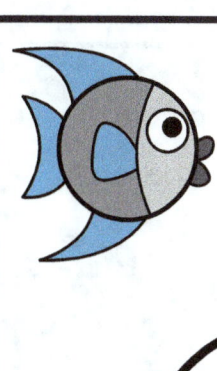

What can you make from a circle?
Follow the directions to draw the fish.

1

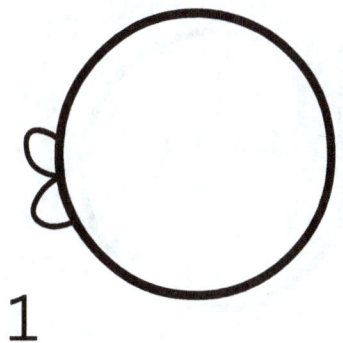

2 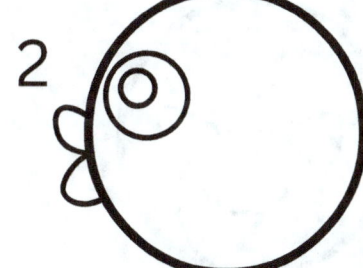 3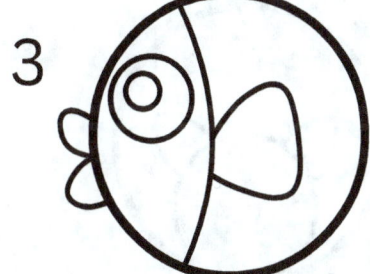

4 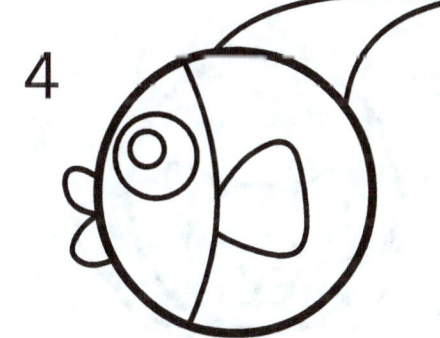 5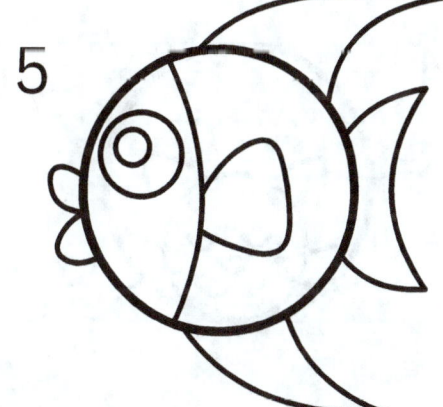

 What can you make from a circle?
Follow the directions to draw the cat.

1

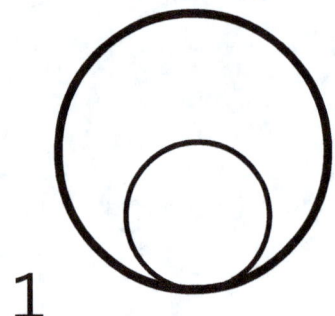

2 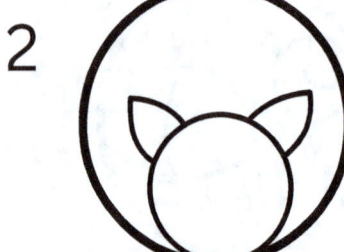 3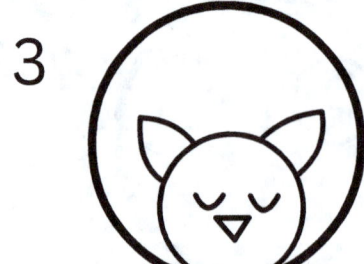

4 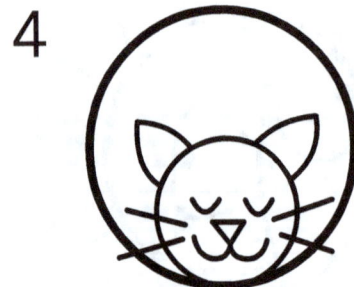 5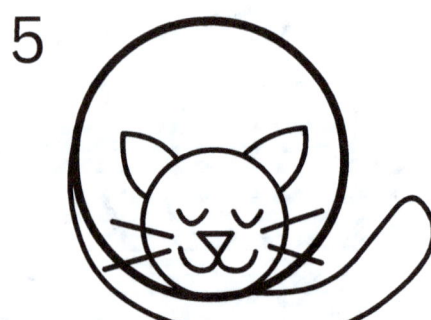

What can you make from a circle?
Follow the directions to draw the pig.

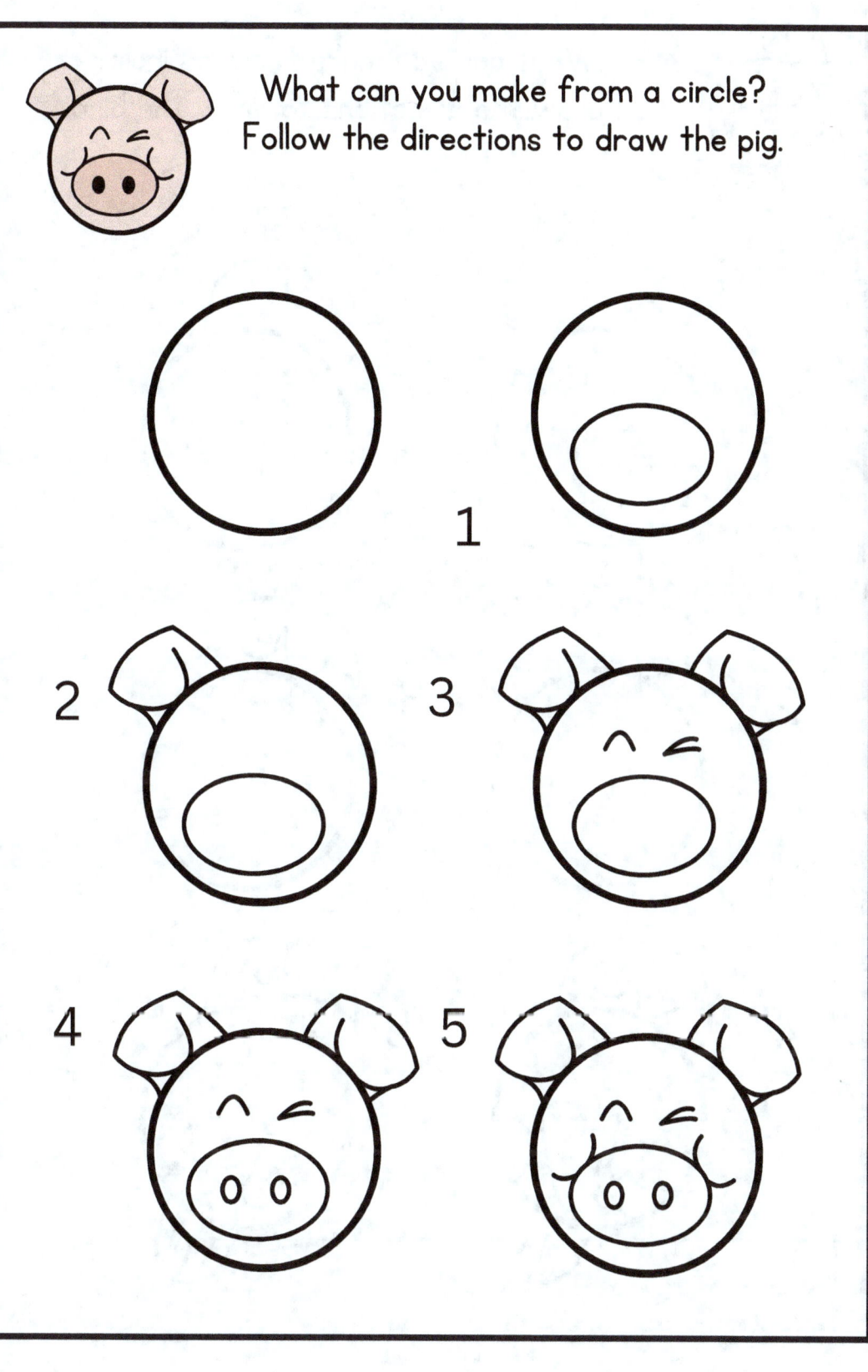

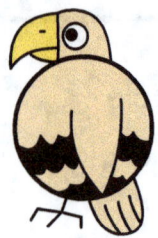

What can you make from a circle?
Follow the directions to draw the bird.

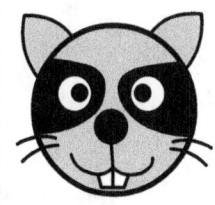 What can you make from a circle?
Follow the directions to draw the mouse.

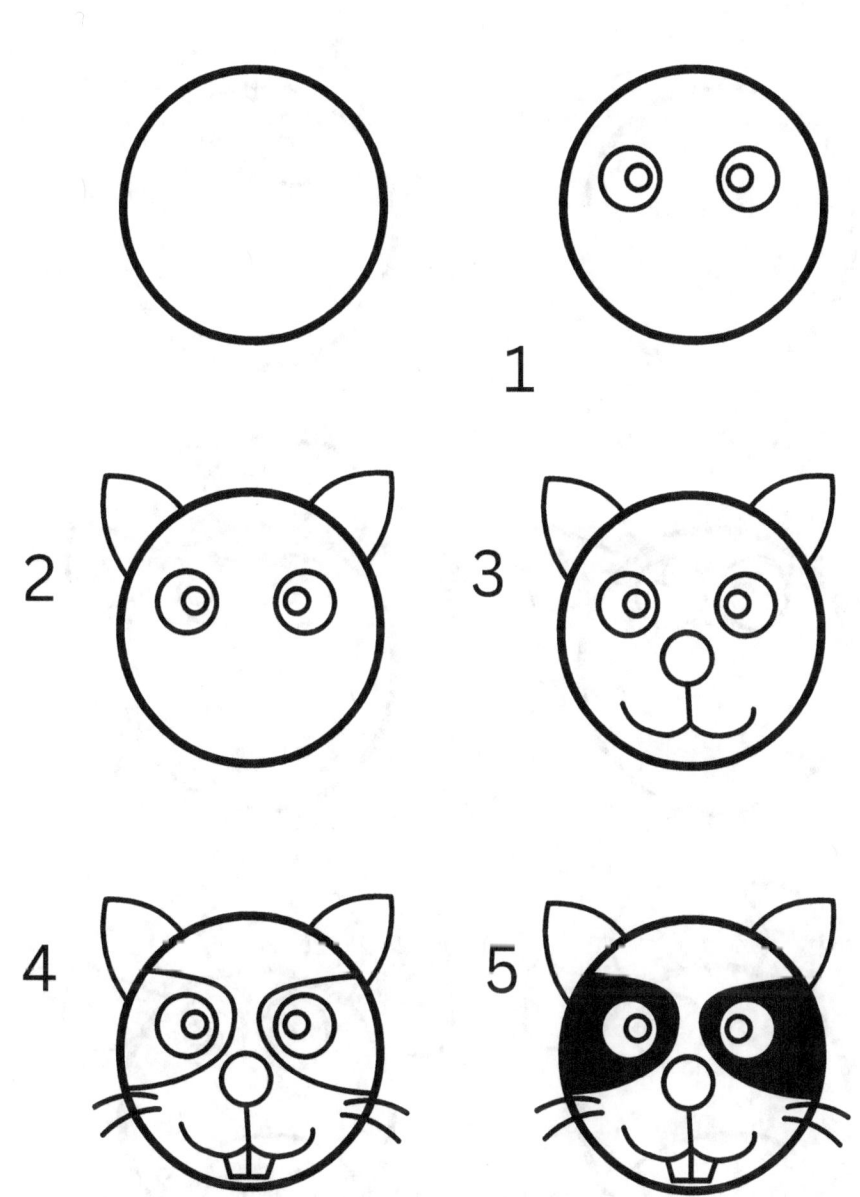

What can you make from a circle? Follow the directions to draw the cow.

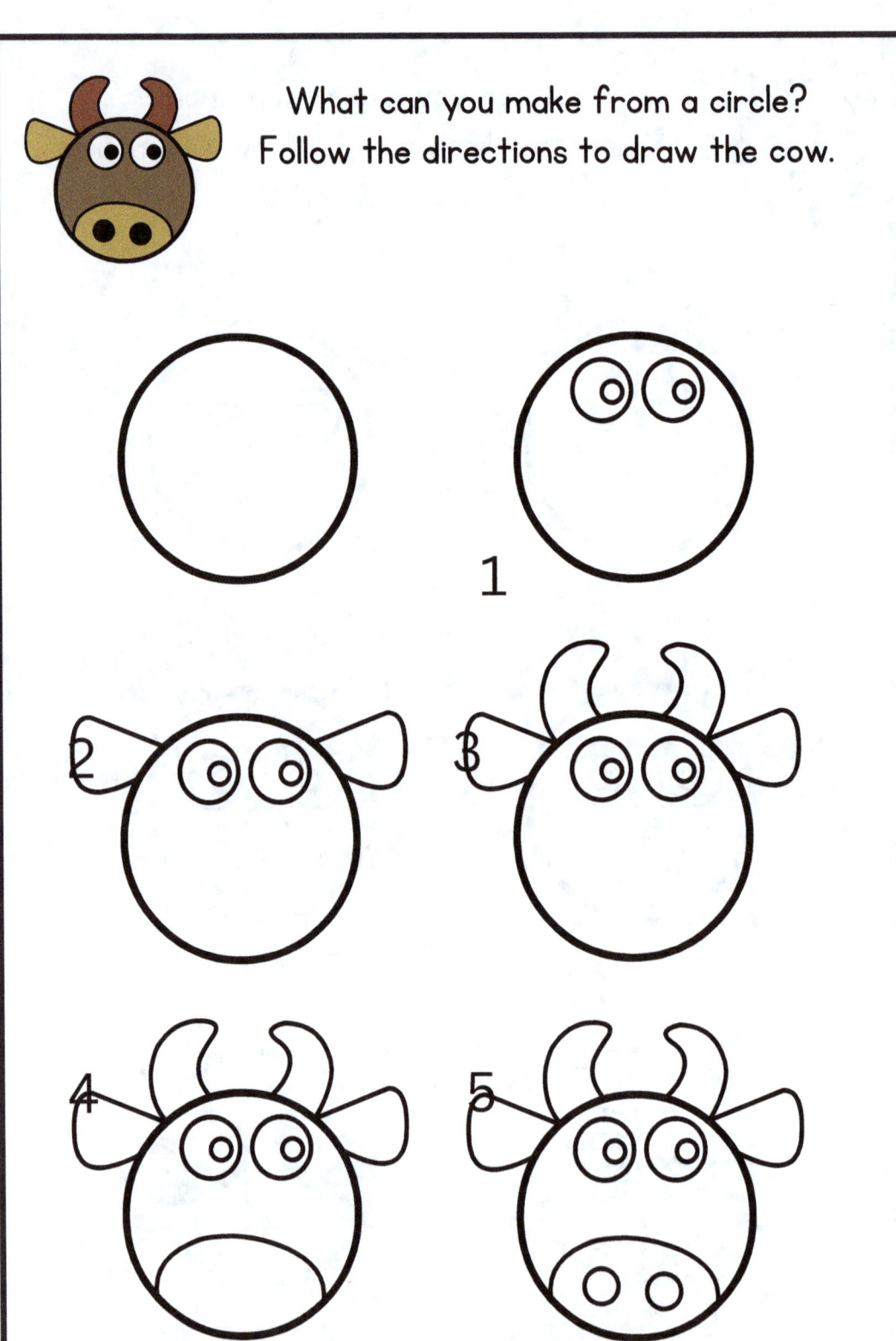

What can you make from a circle?
Follow the directions to draw the rooster.

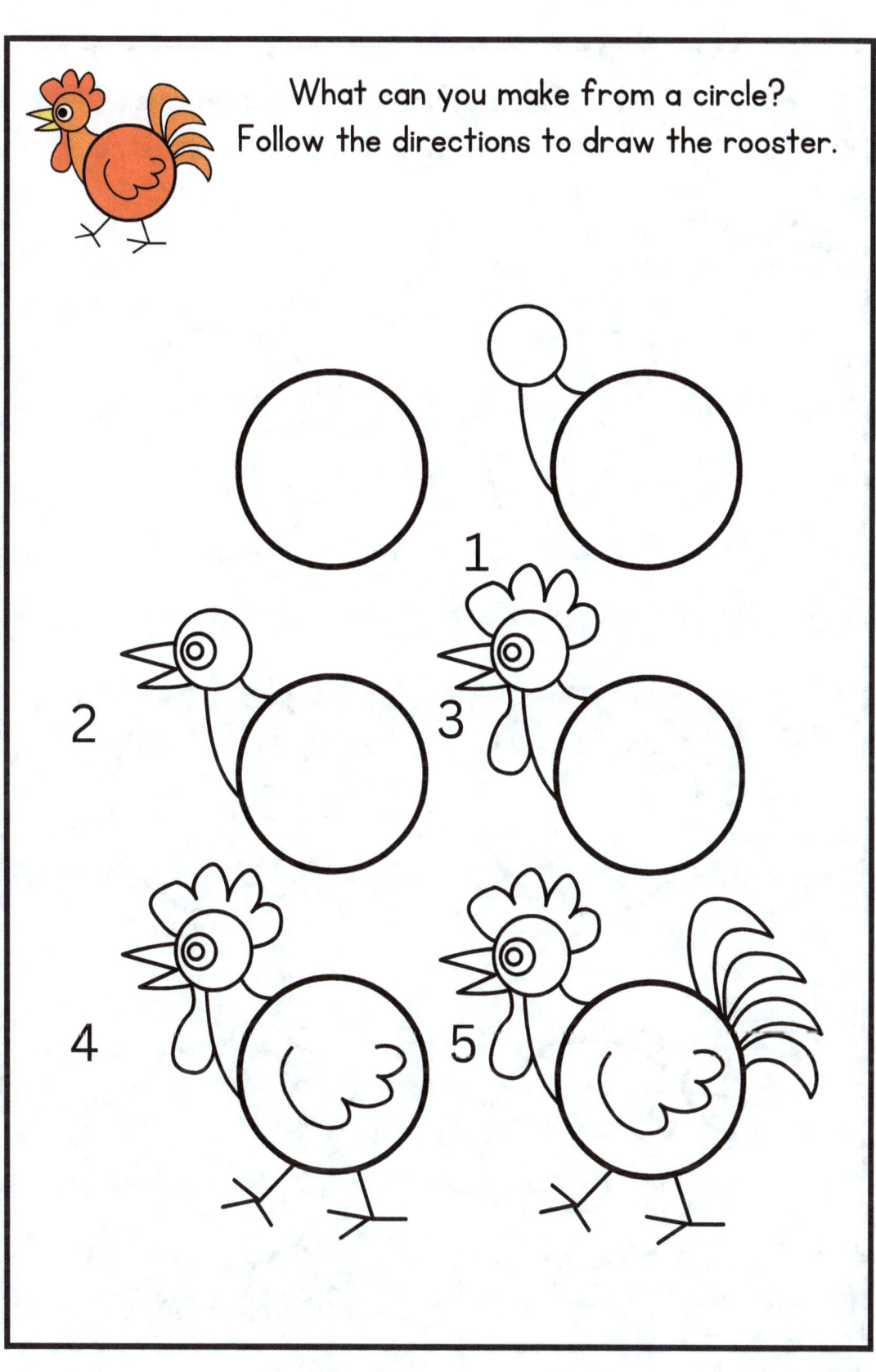

What can you make from a circle?
Follow the directions to draw the hen.

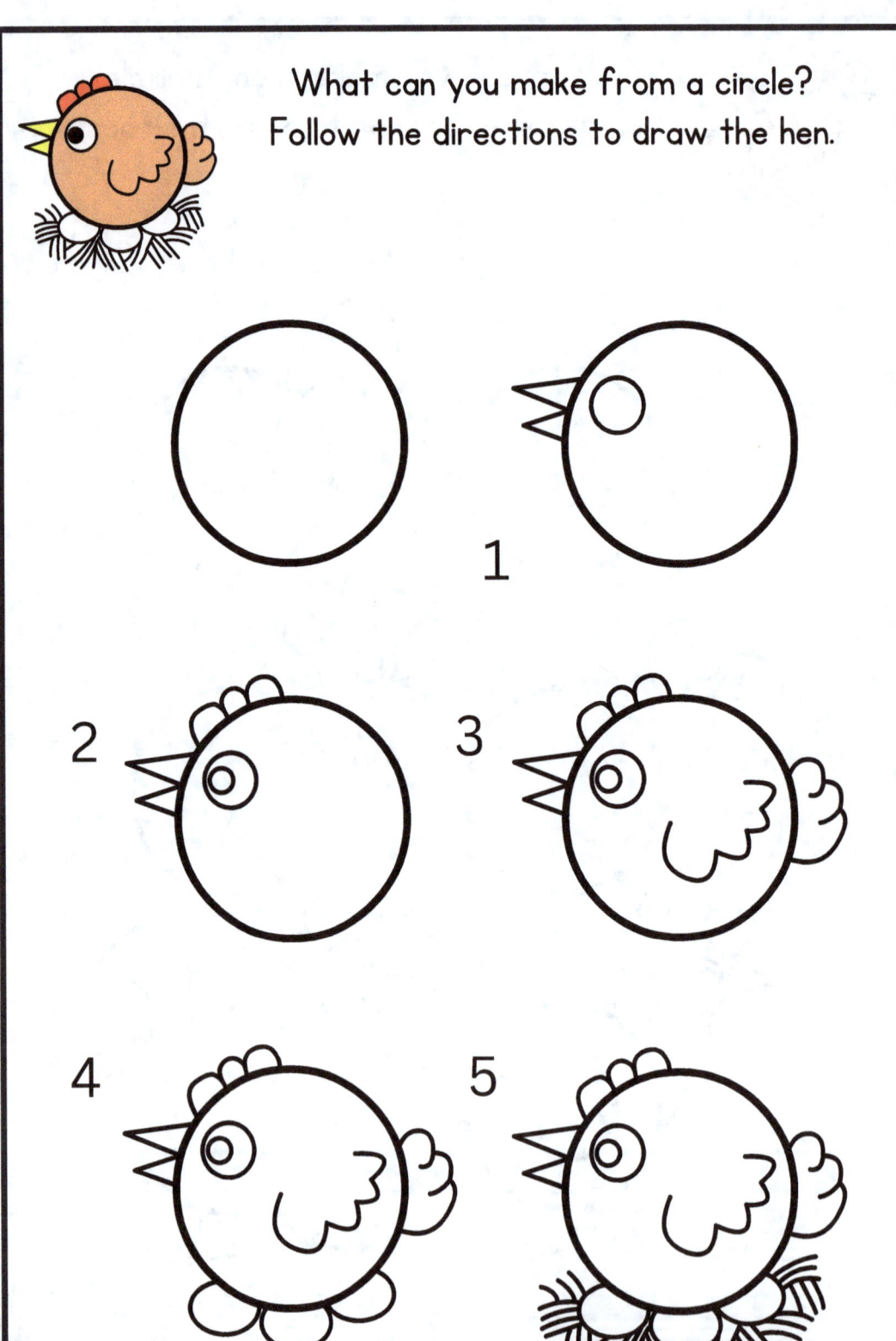

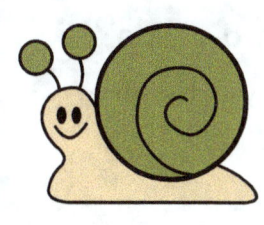

What can you make from a circle?
Follow the directions to draw the snail.

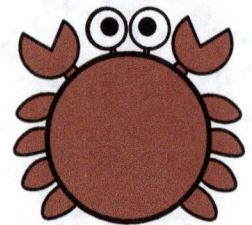 What can you make from a circle?
Follow the directions to draw the crab.

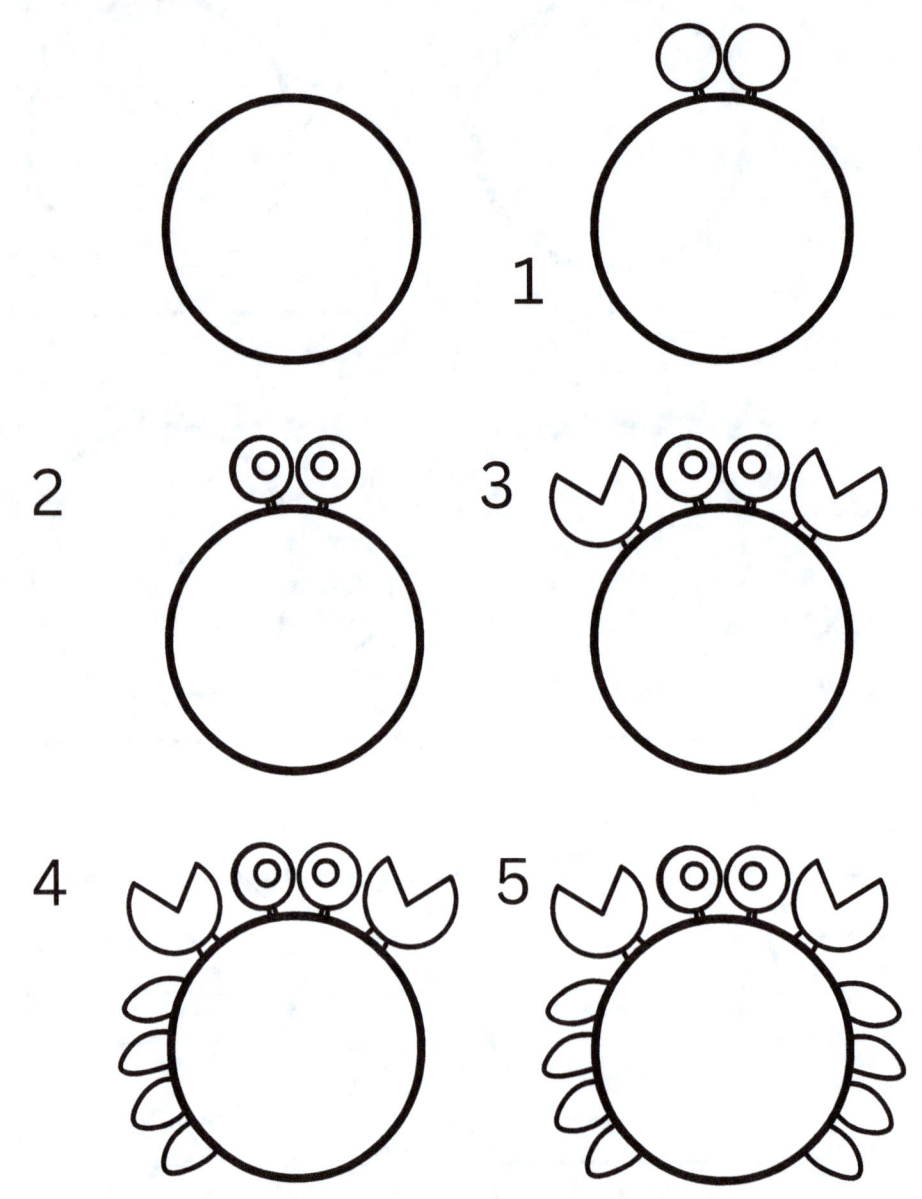

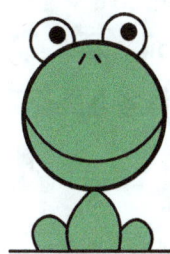 What can you make from a circle?
Follow the directions to draw the frog.

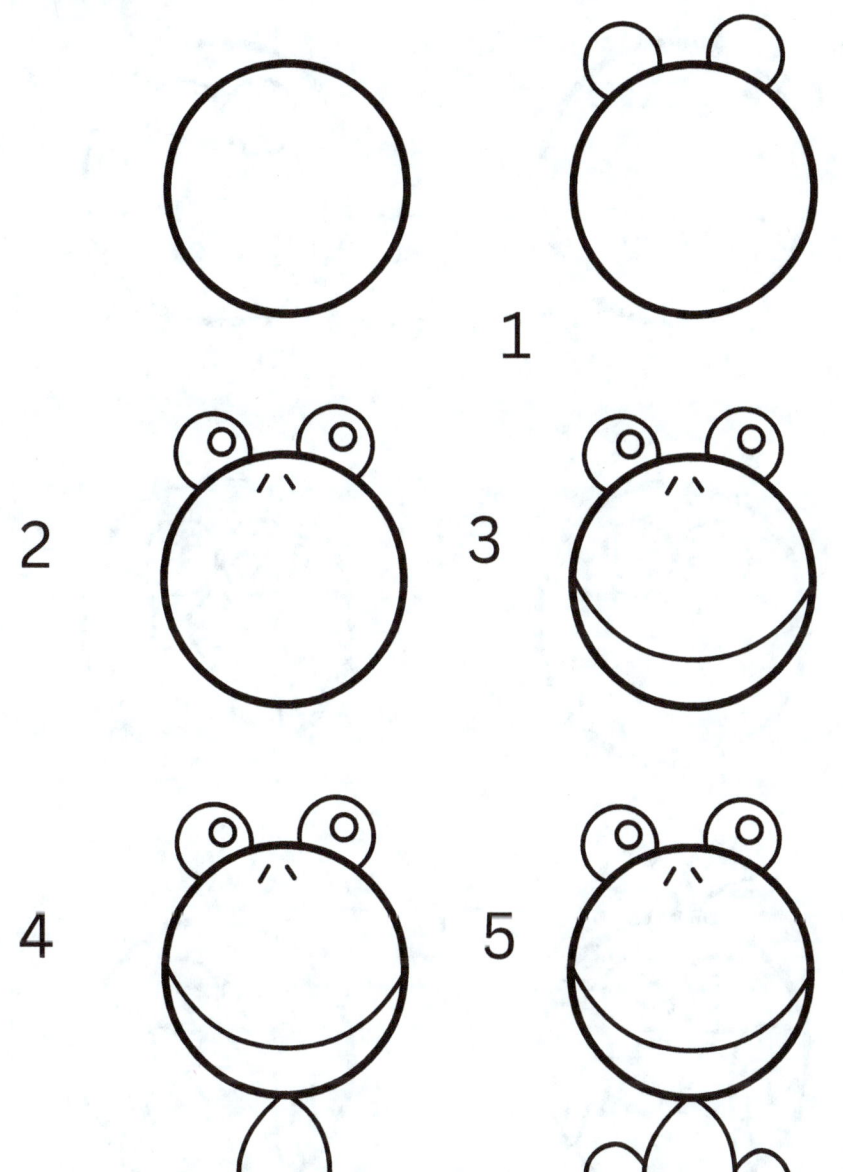

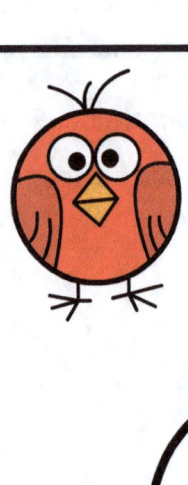 What can you make from a circle?
Follow the directions to draw the bird.

1

 3

2

4 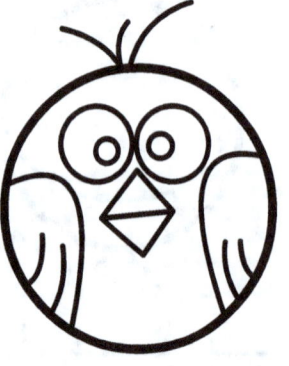 5

TRACE DRAWING

Definition: Trace Drawing involves placing a sheet of paper over a reference image (or using a lightbox or digital tool) and tracing the lines and details from the reference onto the new paper. This technique can be used for both practice and practical purposes, such as transferring designs.

Goals of Tracing Technique

Develop Accuracy: To improve accuracy in reproducing shapes, lines, and proportions. Tracing helps in understanding how to replicate details precisely.

Practice Line Quality: To practice creating clean and accurate lines. Tracing allows you to focus on the quality and consistency of your line work.

Learn Structure and Composition: To gain insights into the structure and composition of a drawing. By tracing, you can analyze how different elements are arranged and how proportions are maintained.

Build Confidence: To boost confidence, especially for beginners. Tracing can help reduce frustration and build skills gradually before moving on to freehand drawing.

Complete the Half

Trace and color the other halves of the pictures.

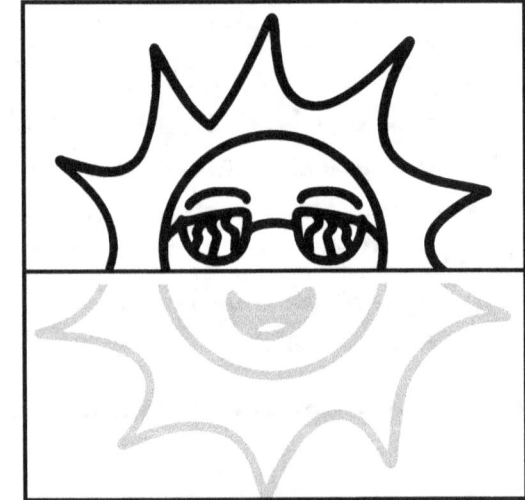

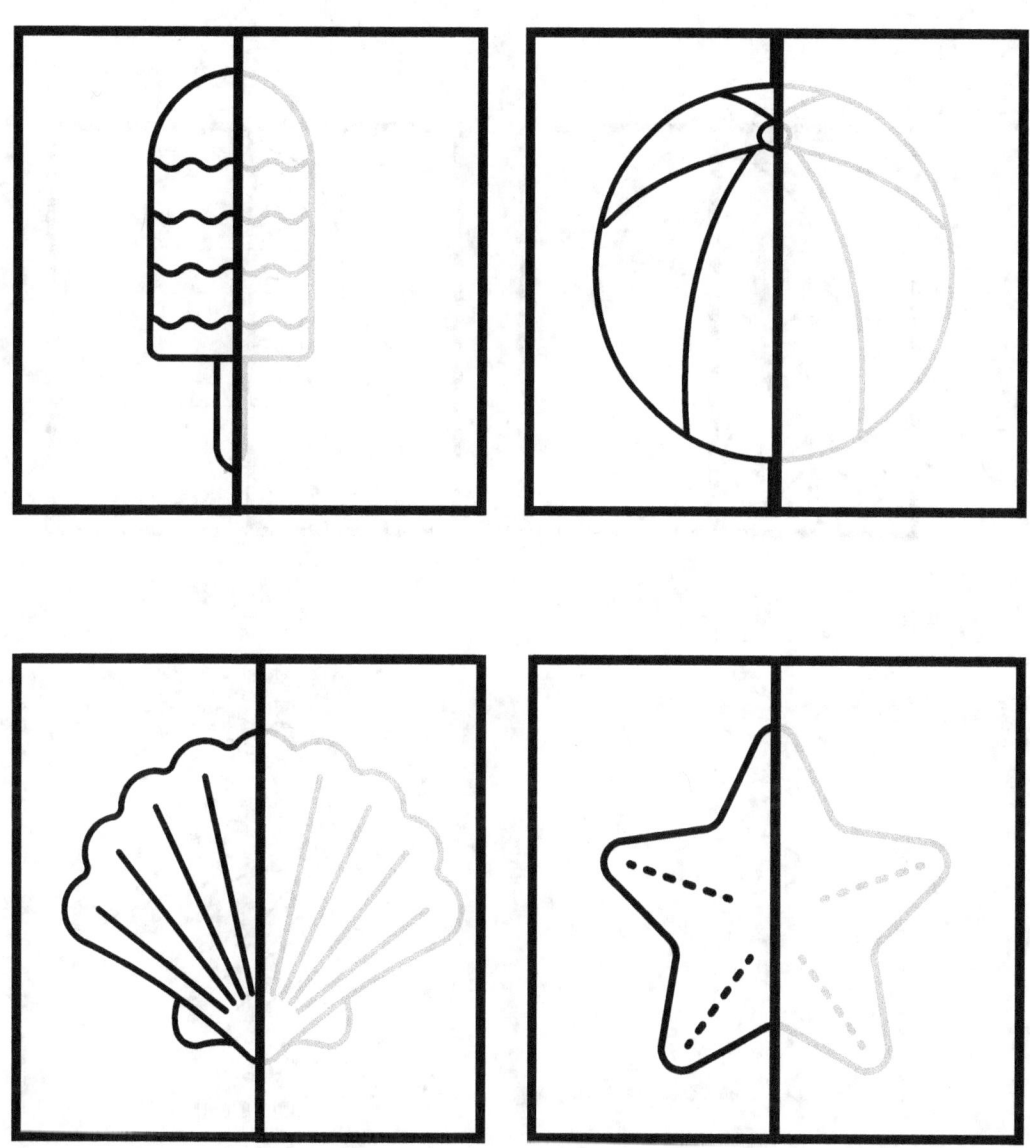

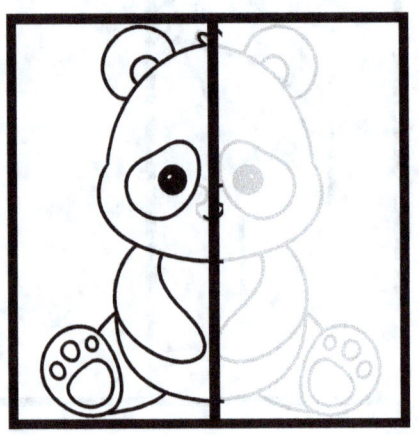
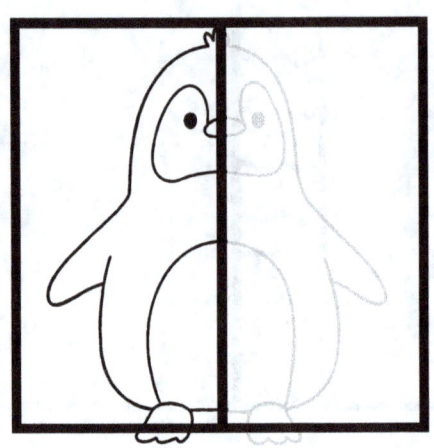
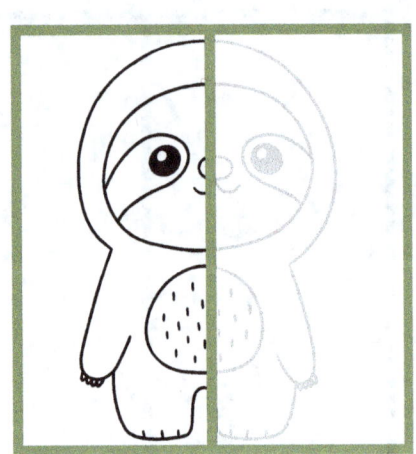
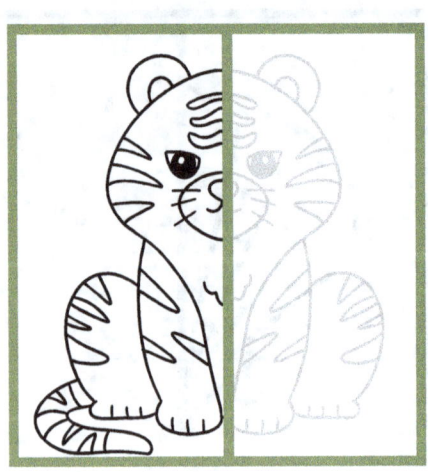

GRID DRAWING

Definition: Grid Drawing involves overlaying a grid on a reference image and a blank drawing surface. The artist then copies the content of each square from the reference image into the corresponding square on the drawing surface. This process simplifies complex images into manageable sections, making it easier to capture accurate proportions and details.

Goals of Grid Technique

Accuracy and Proportion: The grid helps ensure that the drawing is proportionally correct and that details are not lost or distorted.

Simplify Complex Images: To break down complex images into manageable sections, making it easier to focus on one part at a time.

Improve Observational Skills: To enhance observational skills by encouraging artists to carefully study and translate each section of the reference image.

Facilitate Scaling: To enable artists to scale images up or down accurately. By adjusting the size of the grid squares, artists can enlarge or reduce the image while preserving proportions.

Enhance Technique and Precision: Develops technical drawing skills and precision. The method helps in practicing fine motor skills and attention to detail.

How to Use Grid Process in Drawing

- Prepare your drawing surface.
- Draw a grid on your drawing paper that matches the grid on your reference image.

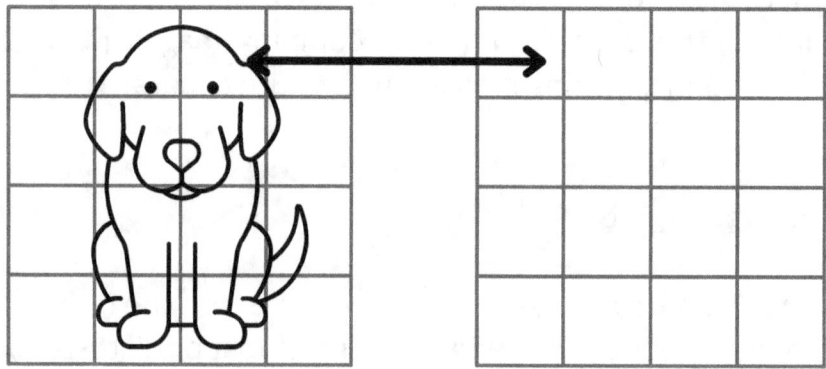

- Ensure the number of squares and the proportion of the grid match the original image.
- Focus on 1 square at a time.
- Look at the corresponding square on the reference image and DRAW WHAT YOU SEE in that square to your paper.

- Move one square to the next, ensuring you are copying every details accurately.

Use the grid outline as a guide to help you draw a dog.

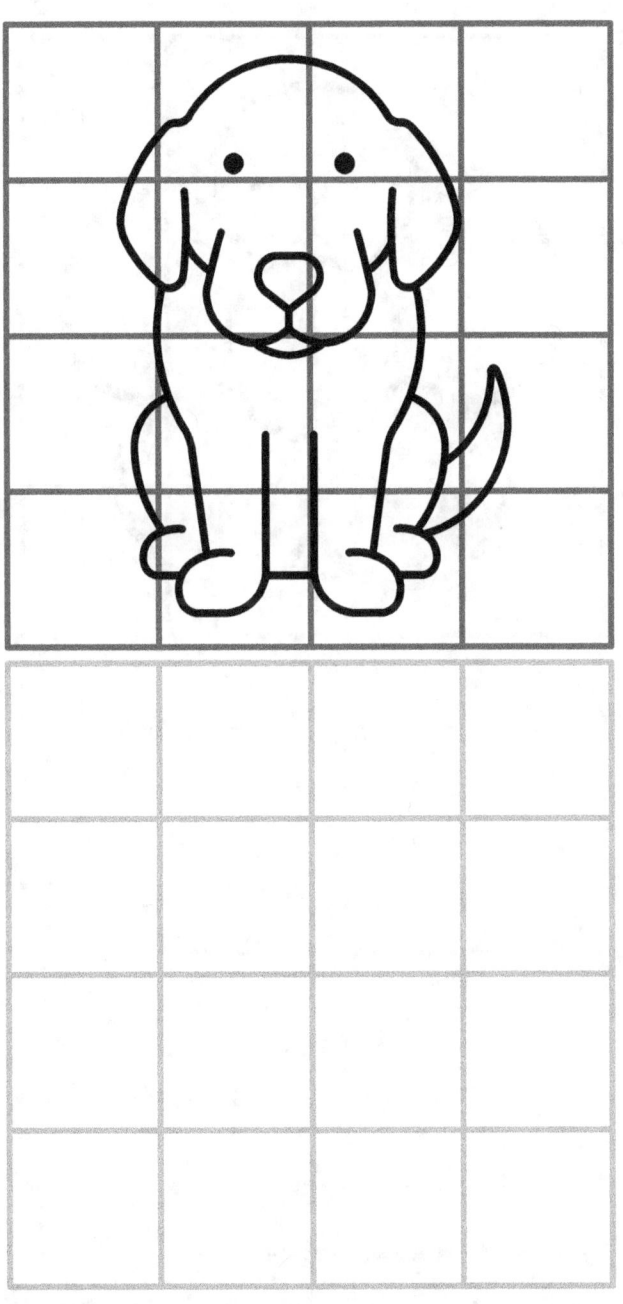

Use the grid outline as a guide to help you draw a flower.

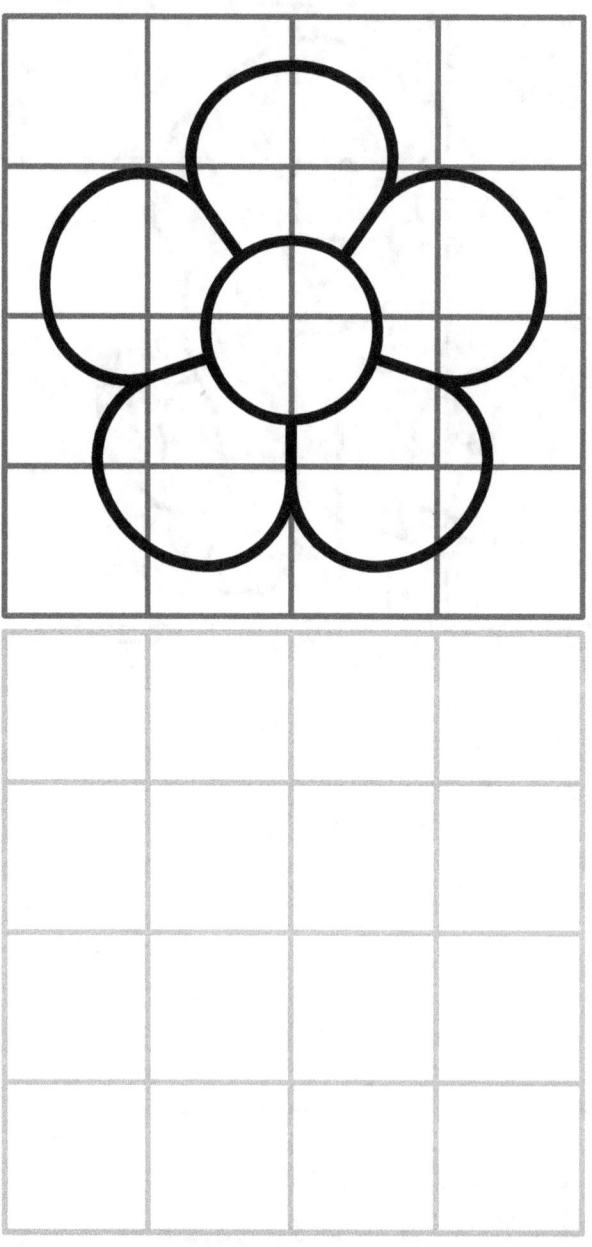

Use the grid outline as a guide to help you draw a house.

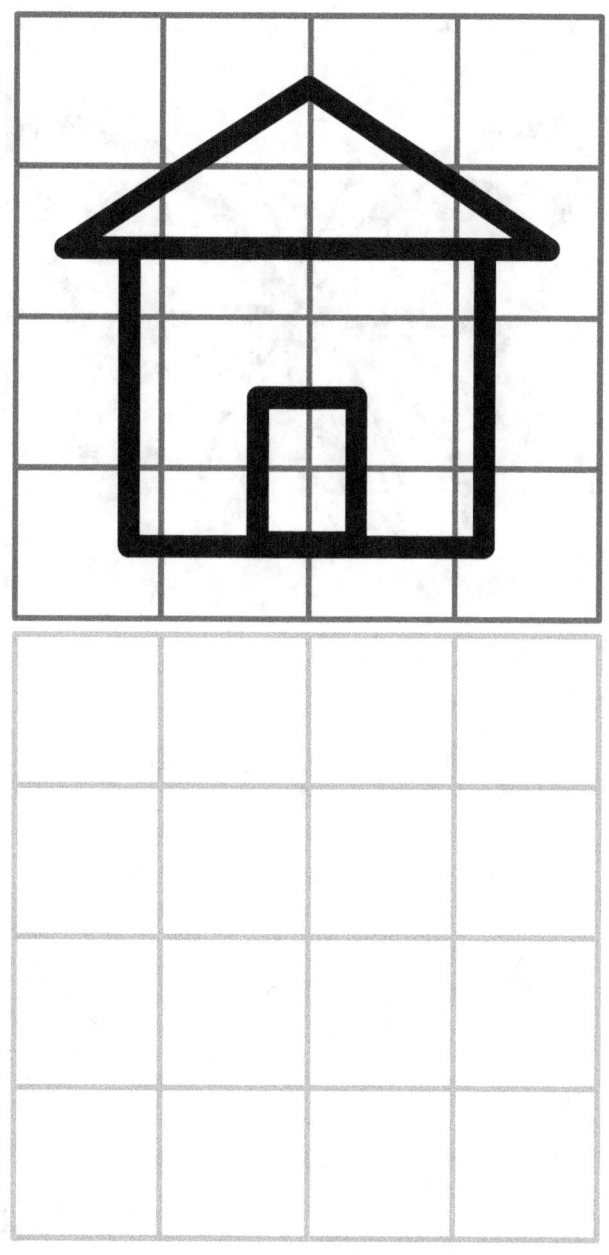

Use the grid outline as a guide to help you draw a butterfly.

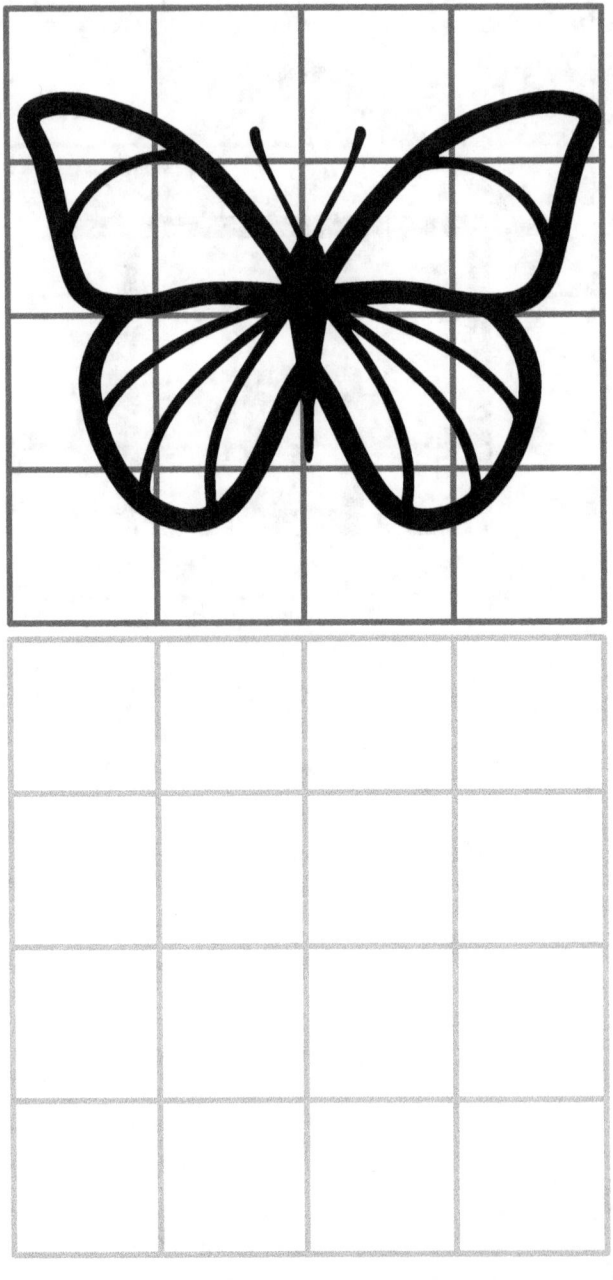

Use the grid outline as a guide to help you draw a tree.

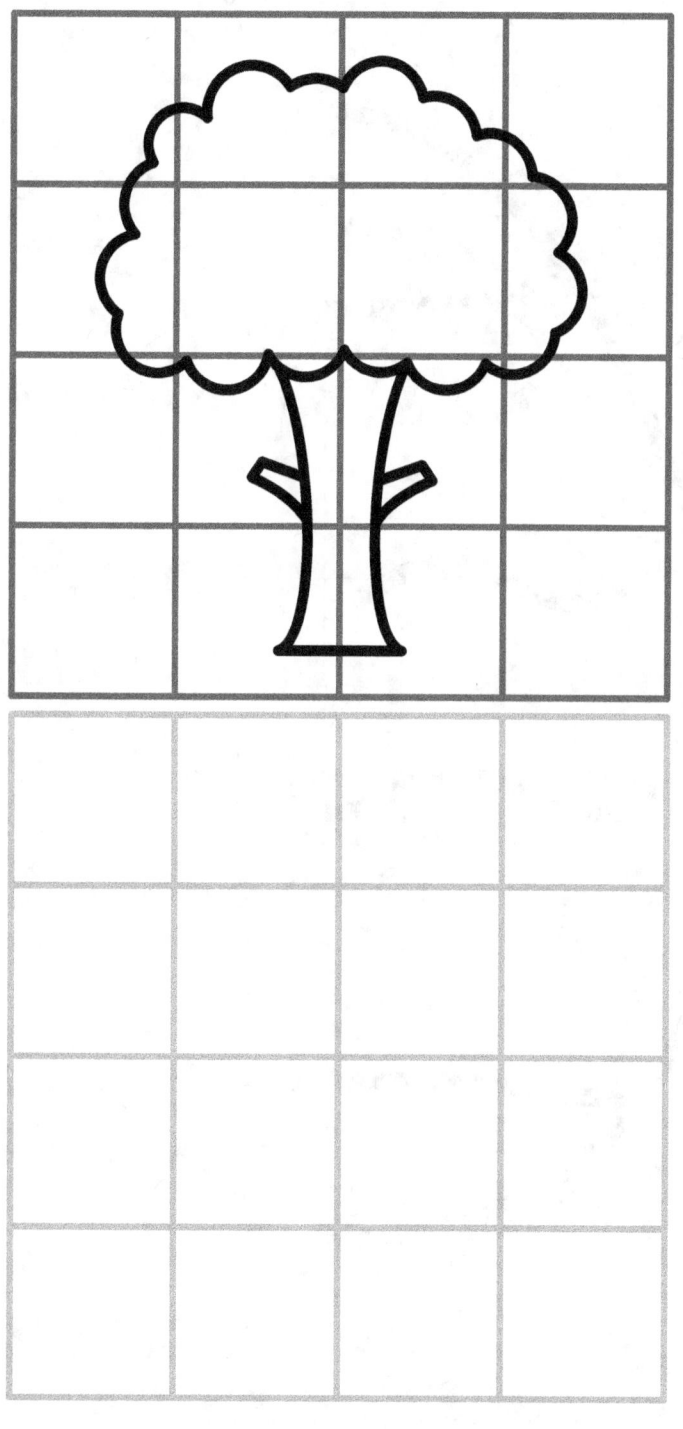

Grid Drawing - Complete the half

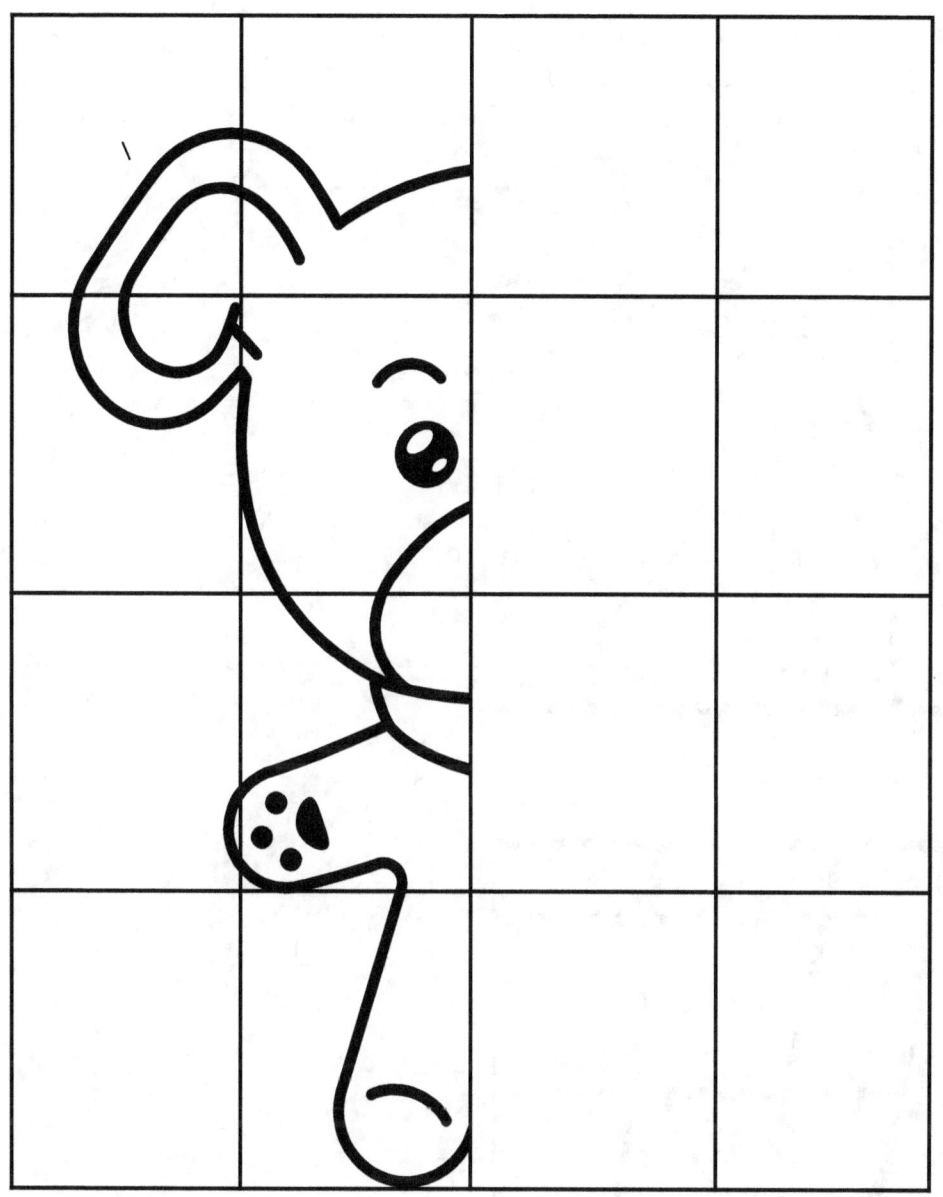

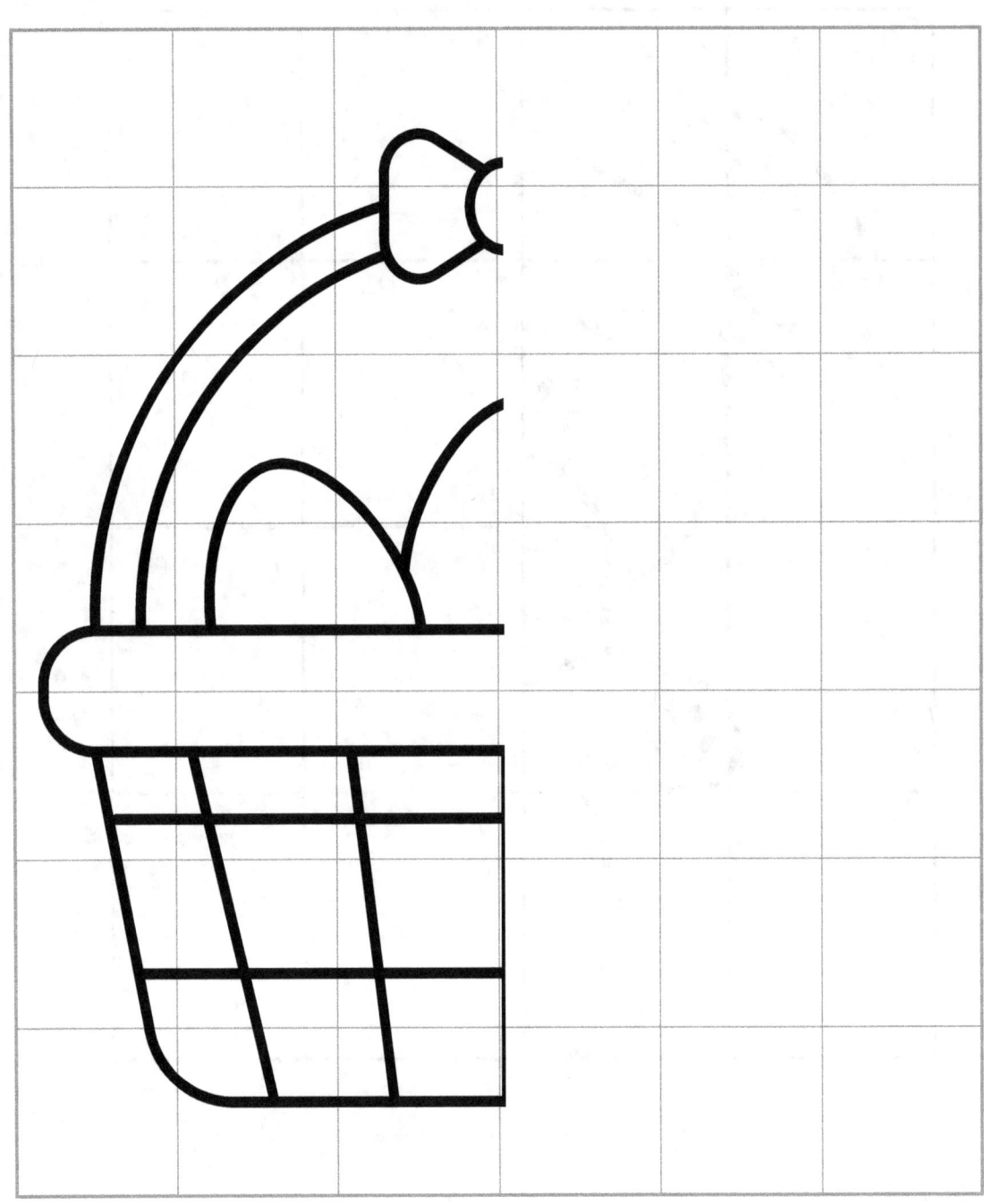

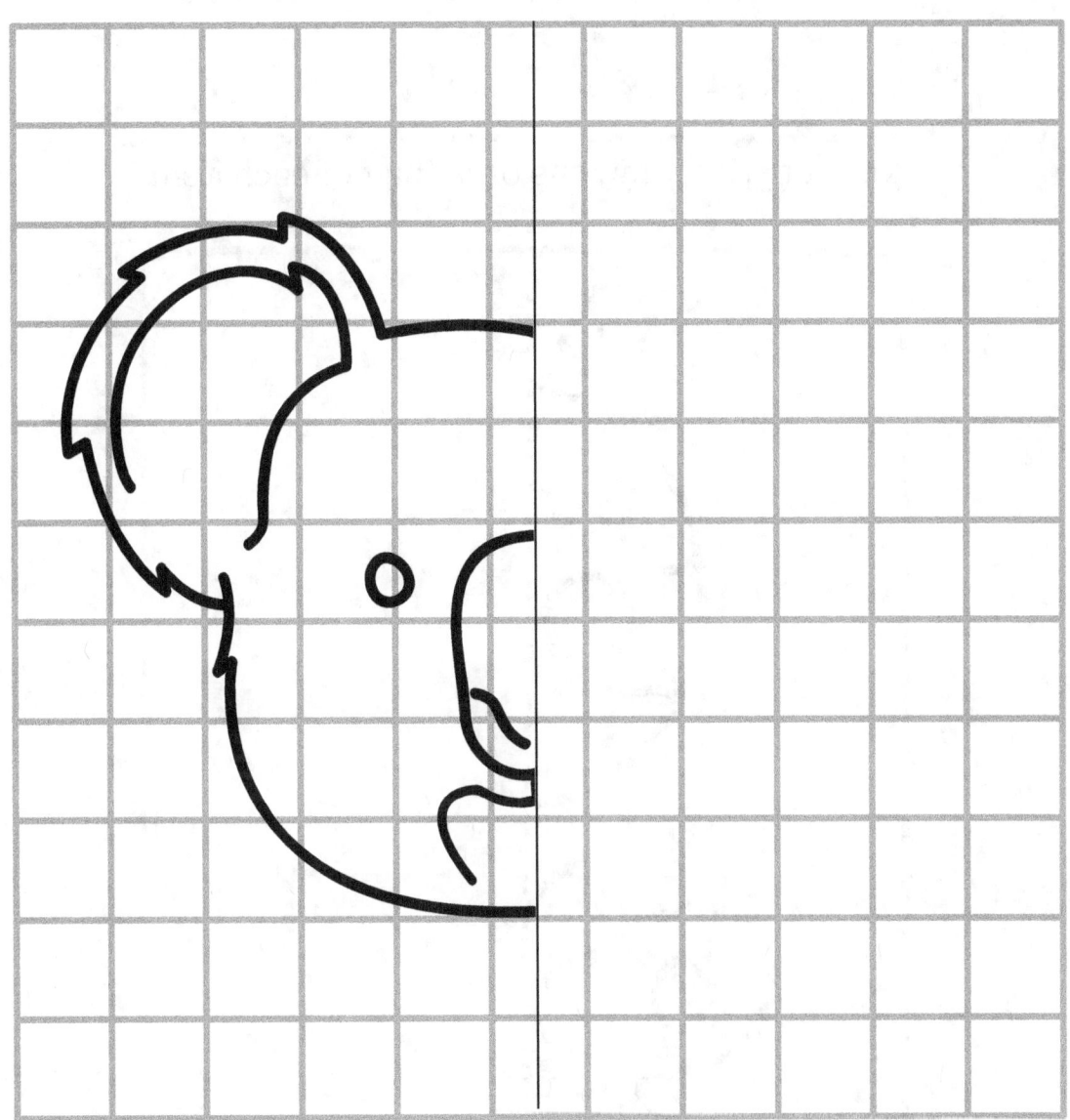

Draw without Grids

Without grids, draw the other half of each item.

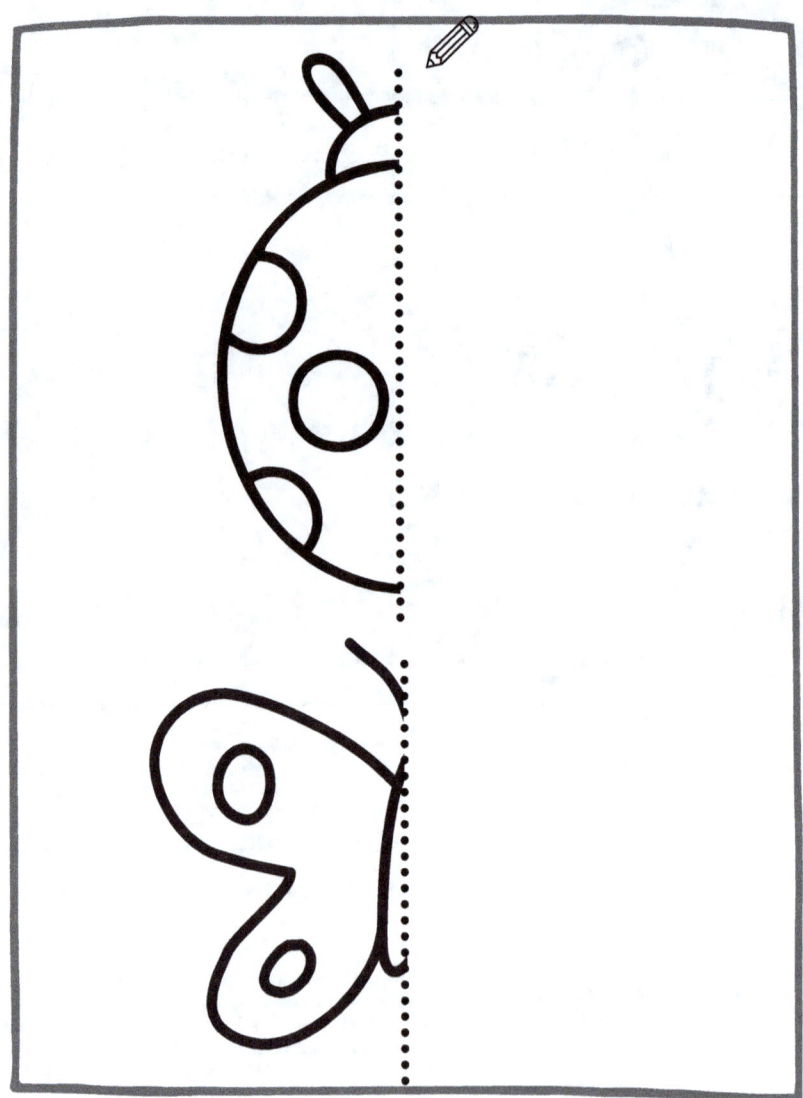

Reference Image

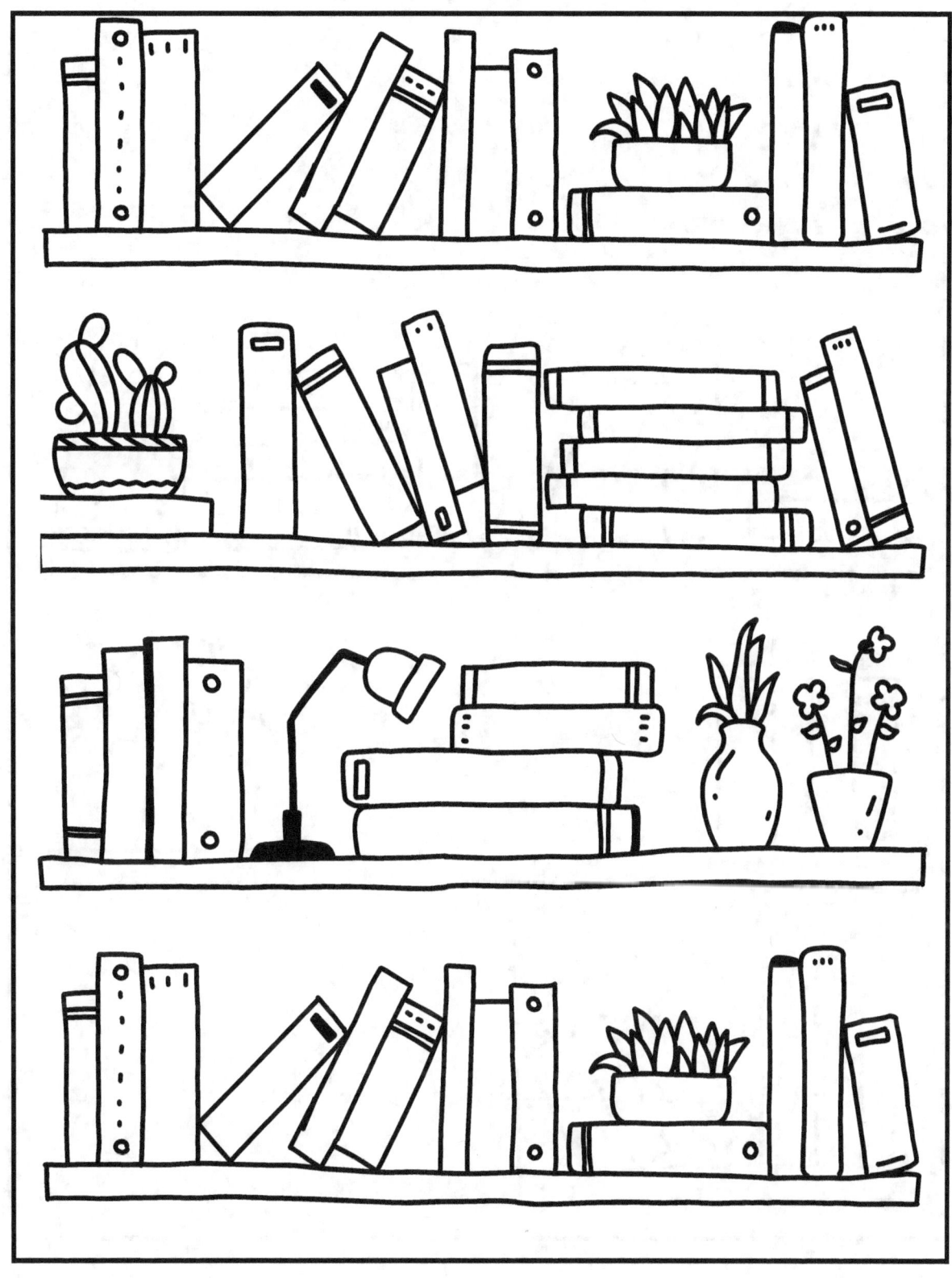

Refer to Previous Page to Complete this Image

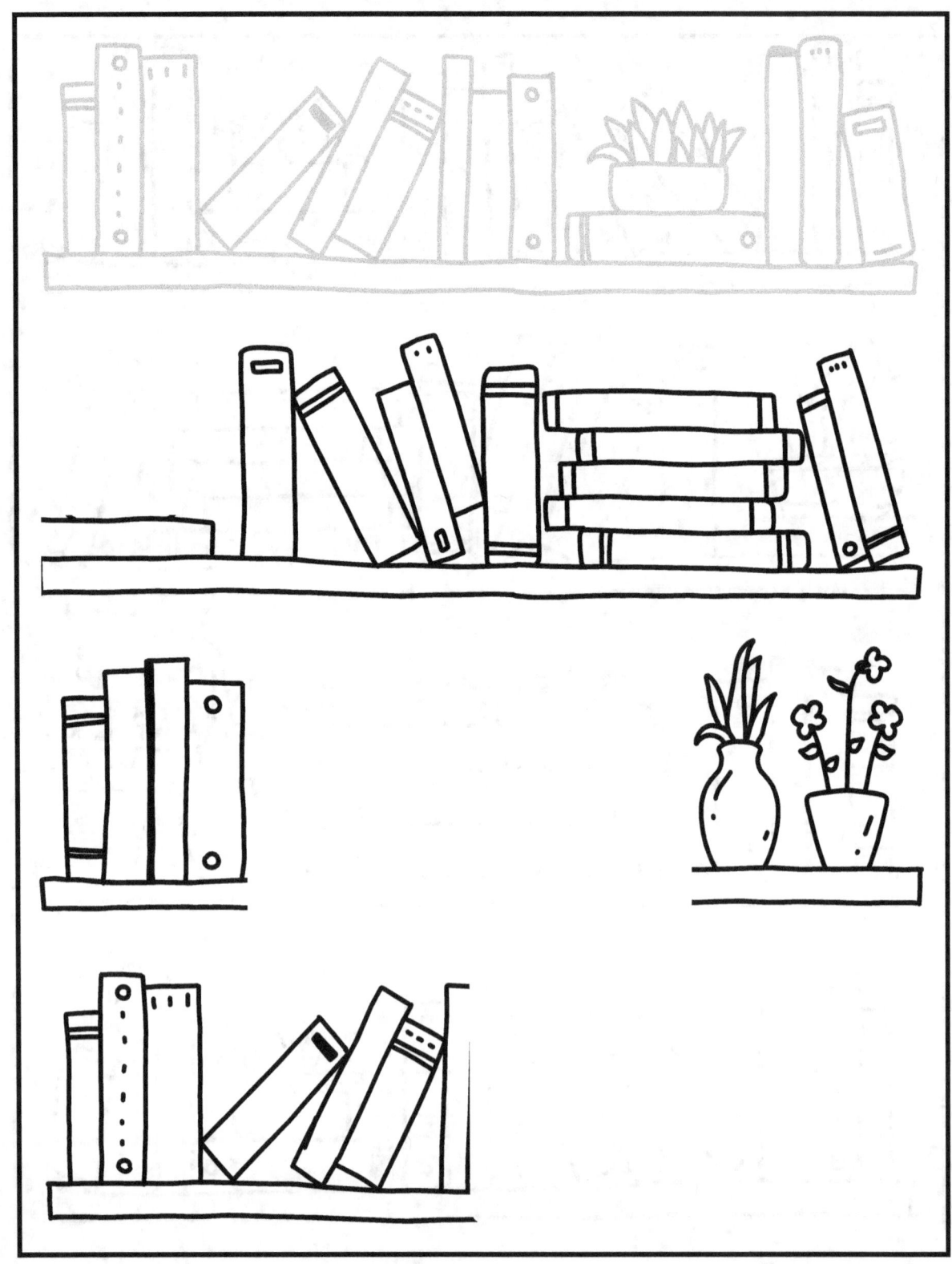

Drawing with Shapes is an artistic approach that involves using basic geometric shapes—such as circles, squares, triangles, and rectangles. This technique simplifies the drawing process by breaking down complex images into fundamental forms.

Importance of Drawing with Shapes

Simplify Complex Images: To make complex subjects more manageable by breaking them down into simple, recognizable shapes. This approach helps in understanding and capturing the basic structure of the subject.

Develop Confidence: To build confidence in drawing by providing a structured approach that simplifies the process and reduces the complexity of starting a new artwork.

Increase Accuracy: To enhance accuracy in capturing the overall structure of the subject. Starting with basic shapes allows for corrections and adjustments early in the drawing process.

Build Drawing Skills: To build foundational drawing skills by focusing on the fundamental aspects of shape and form. This technique provides a clear framework for beginners to practice and improve their drawing abilities.

Draw Using Shapes

Draw fishes using the shapes below.

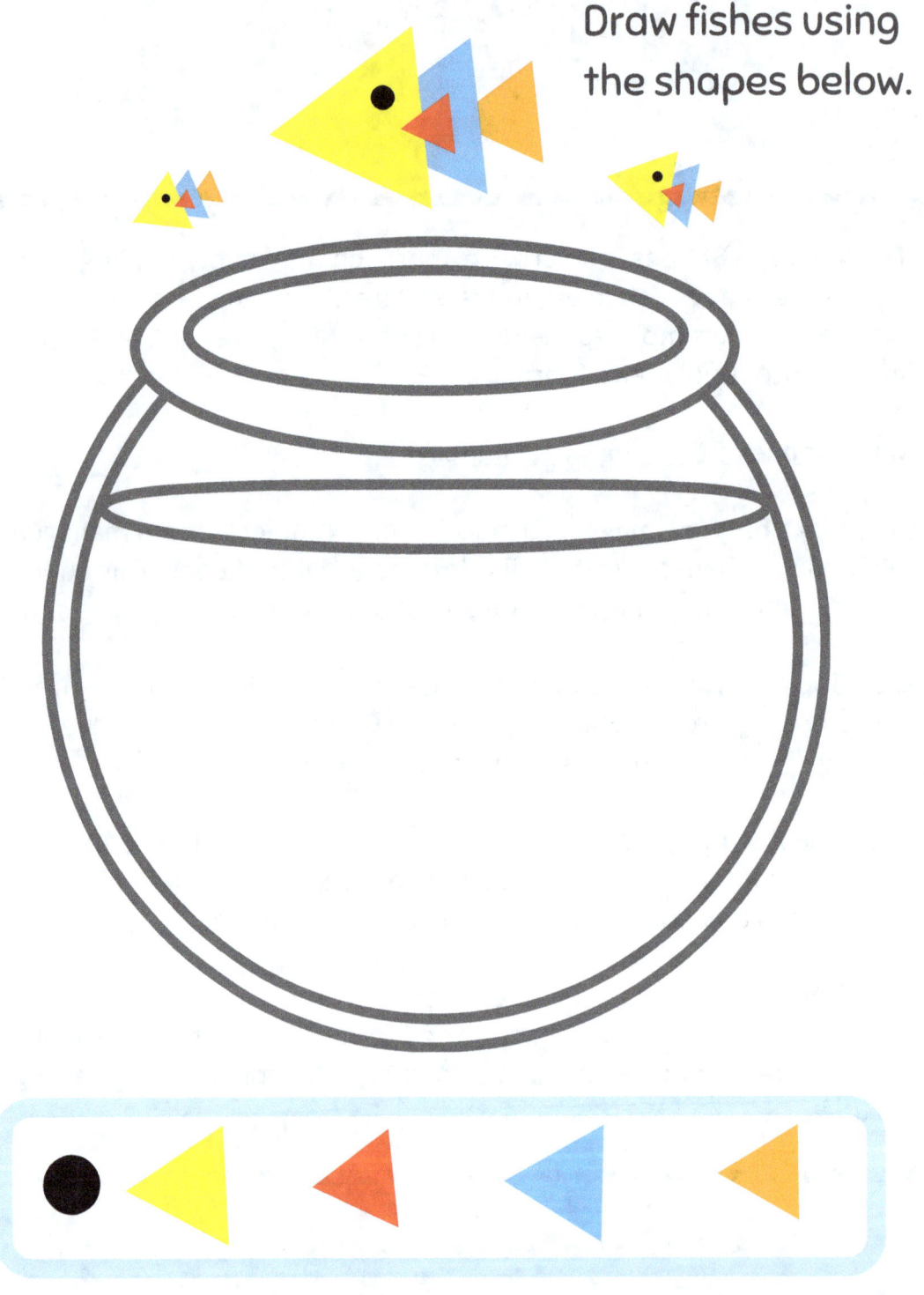

INSTRUCTIONS

Draw a robot using shapes. Start by selecting the shapes that you will use to create your robot. You can use any of the shapes shown in the shape key. Draw your robot in the space below.

SHAPE KEY

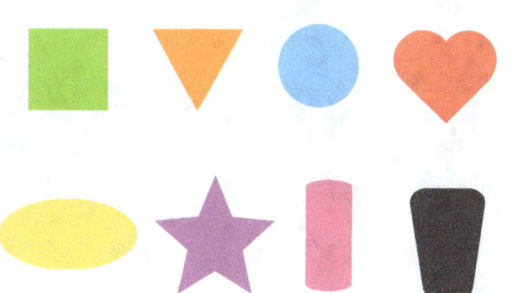

GEOMETRIC SYMMETRY CHALLENGE

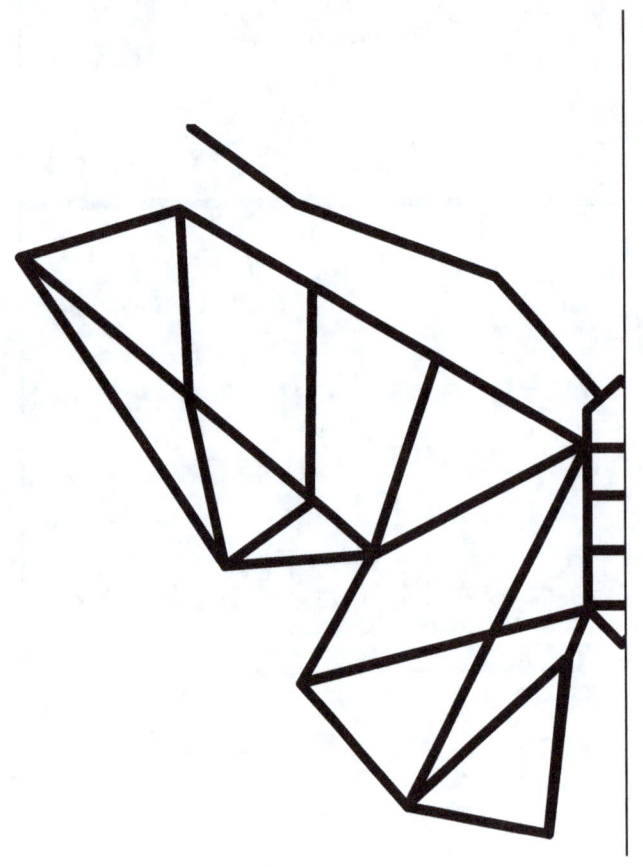

LET'S DRAW & COLOR

Draw and paint the barn in four steps.

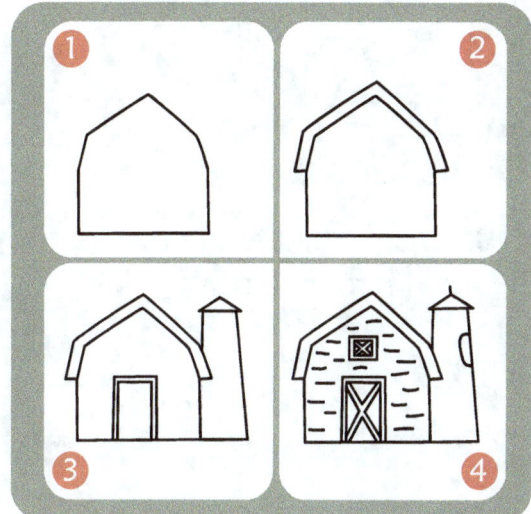

Drawing Area

LET'S DRAW & COLOR

Draw and paint the horse in four steps.

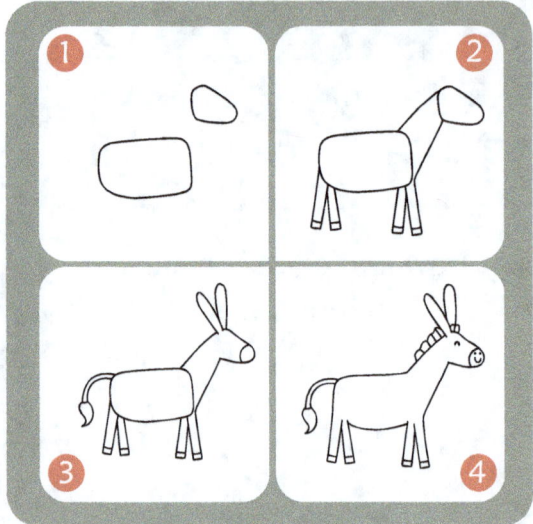

Drawing Area

LET'S DRAW & COLOR

Draw and paint the windmill in four steps.

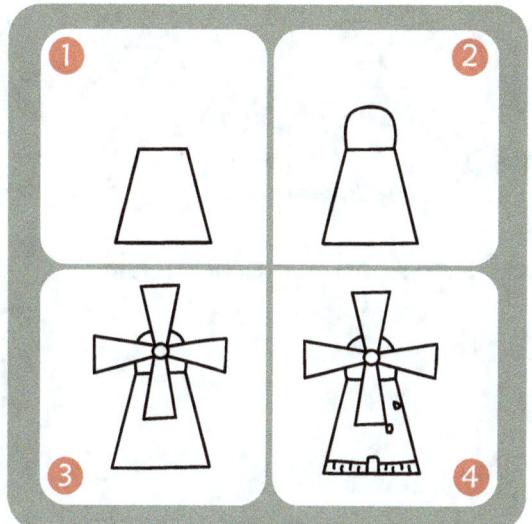

Drawing Area

LET'S DRAW & COLOR

Draw and paint the truck in four steps.

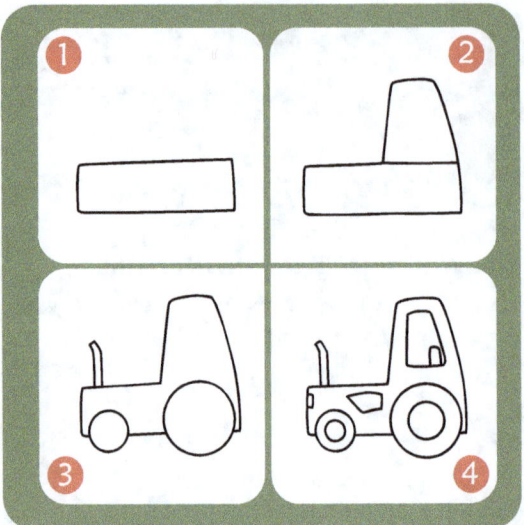

Drawing Area

LET'S DRAW & COLOR

Draw and paint the farmer and tractor in four steps.

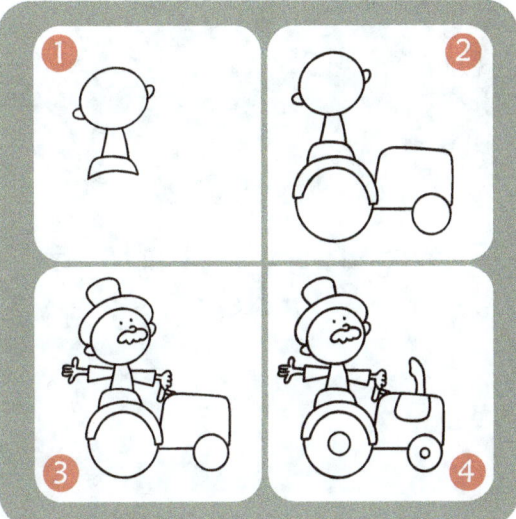

Drawing Area

LET'S DRAW & COLOR

Draw and paint the tractor in four steps.

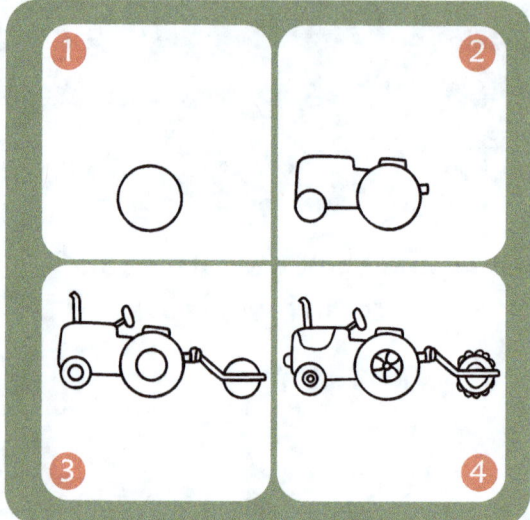

Drawing Area

LET'S DRAW & COLOR

Draw and paint the wind vane in four steps.

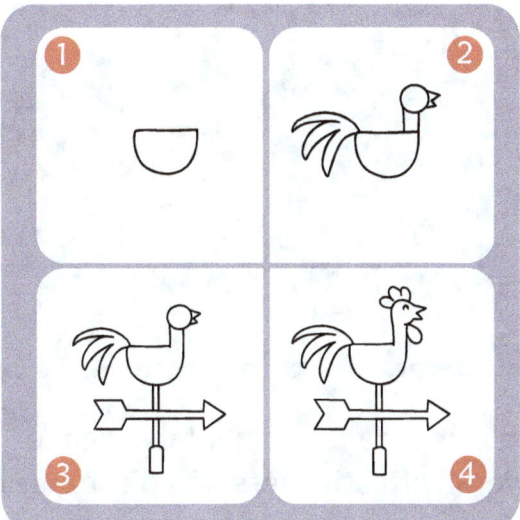

Drawing Area

COLORING PRACTICE

Coloring is a fundamental aspect of art that significantly impacts the overall effectiveness of a piece. For beginners, mastering coloring techniques is crucial.

Importance of Coloring in Art

Enhances Visual Appeal: Effective use of color can make artwork more engaging and visually appealing. Learning how to choose and apply colors correctly helps create more vibrant and striking pieces.

Improves Observation Skills: Coloring encourages careful observation of how colors interact with one another, helping artists to notice subtle differences and nuances.

Builds Technique Skills: Practicing coloring helps in developing more advanced techniques such as blending, shading, and layering, which are essential for creating depth and dimension in art.

Aids in Emotional Expression: Colors can convey mood and emotion. Understanding how to use color effectively allows beginners to express feelings and concepts more clearly through their artwork.

RAINBOW COLORS

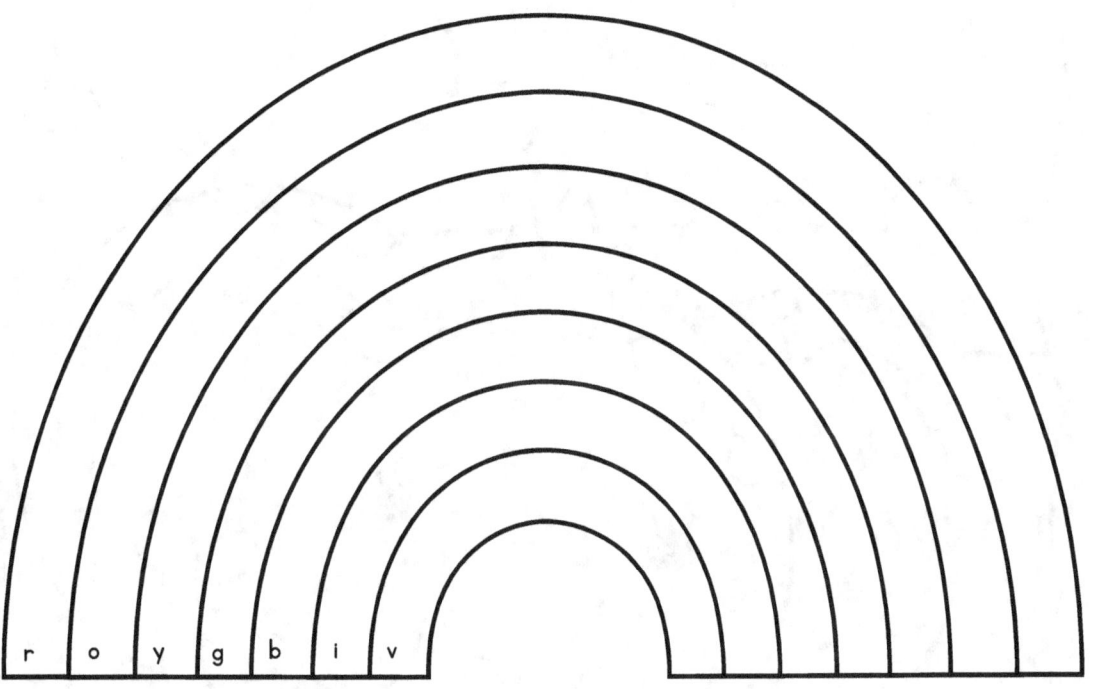

Color the rainbow according to its corresponding colors.

Copy the Colors

You will need these colors:

Copy the Colors

You will need these colors:

Copy the Colors
You will need these colors:

Copy the Colors

You will need these colors:

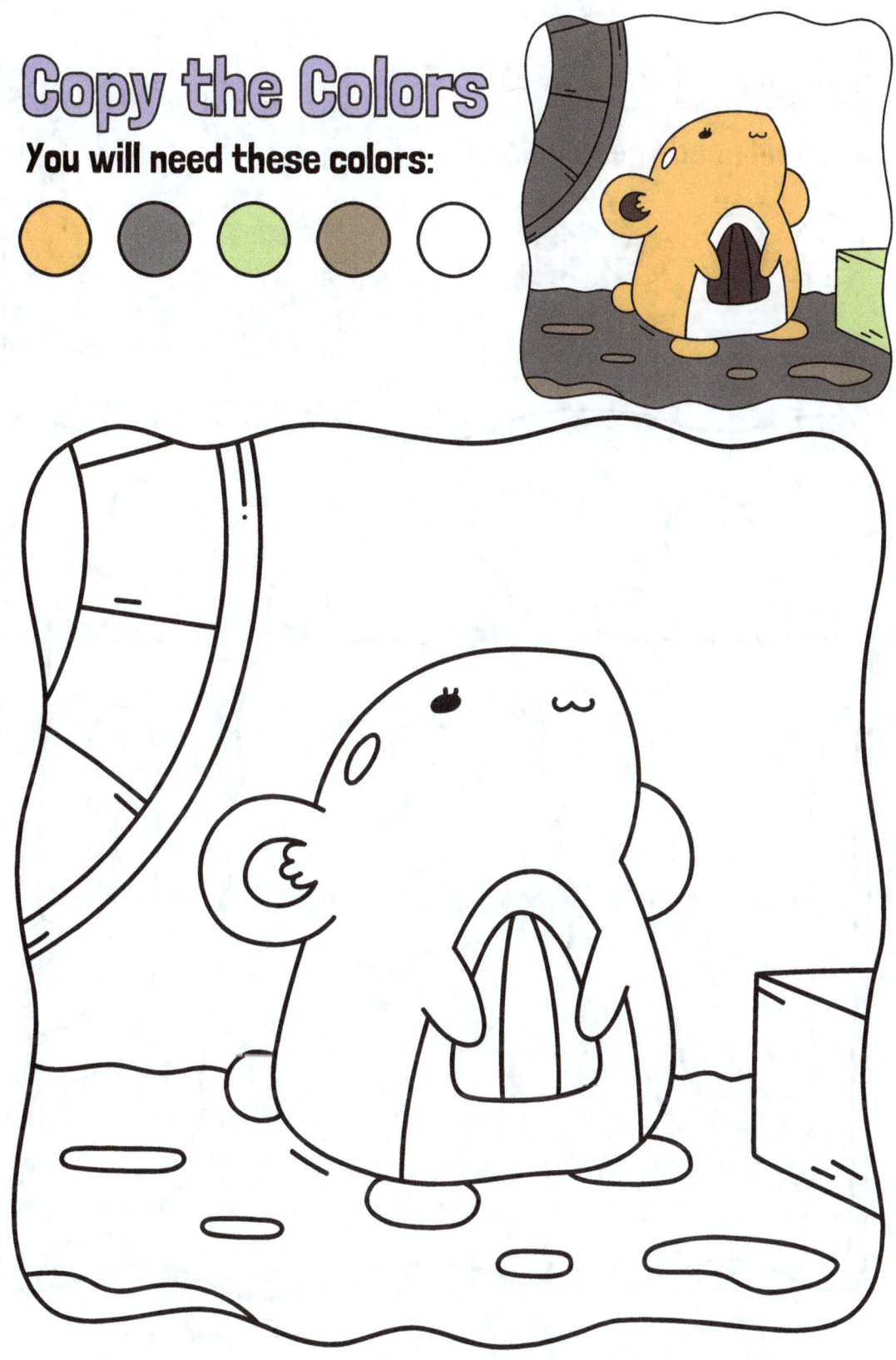

Copy the Colors

You will need these colors:

Copy the Colors

You will need these colors:

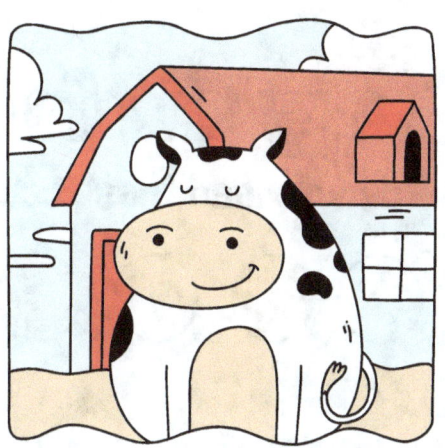

Copy the Colors
You will need these colors:

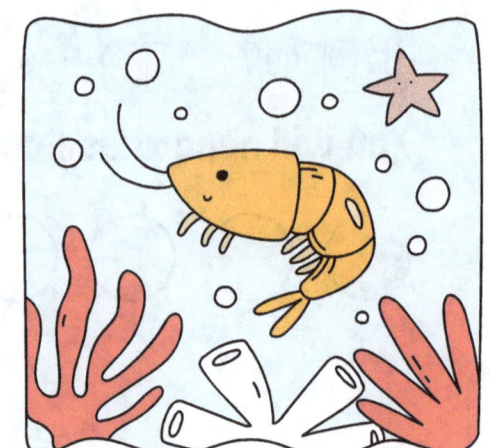

Copy the Colors
You will need these colors:

DRAWING PROMPTS

Definition: A drawing prompt is a specific idea or concept provided to inspire and guide a drawing exercise. It can be a word, phrase, image, or theme meant to spark creativity and help artists practice their skills.

Importance for Beginners

Sparks Creativity: For beginners who may struggle with coming up with ideas, prompts provide a starting point and help overcome creative blocks.

Focuses Practice: Prompts can direct practice on particular elements or techniques, such as shading, perspective, or character design, aiding in targeted skill development.

Encourages Experimentation: By working on varied prompts, beginners are encouraged to explore different styles, subjects, and media, broadening their artistic range.

Builds Confidence: Completing drawings based on prompts can boost confidence as beginners see tangible results and improvements in their work.

Creates Structure: Prompts offer a structured approach to practice, making it easier for beginners to maintain a consistent drawing routine and track progress.

My Self Portrait

Using the picture below, draw yourself – make sure to think carefully about colors and shapes.

My Favorite Person

In the frame below, using the previous grid exercises, can you draw someone special for you?

My Room

Draw how your room looks like and color it with rainbow colors.

My Birthday Cake

Draw and design what you want to see in your cake.

Out My Window, I see...
Draw what you see outside your window.

If I have a Farm

Using the directed drawing exercises,
Draw your ideal farm animals.

My Favorite Animals
Draw your favorite animals at the zoo.

I Live in a Castle

Using grid, draw a floating castle.

Under the Sea
Draw anything you see under the sea.

Treasure Map

Using lines and shapes, draw a map where you have hidden your treasure chest.

Ship Me!

Draw a ship that can take you around the world!

DATE FINISHED: _____

ART REFLECTION
SELF CRITIQUE SHEET

I'm really proud of the way I...

My learnings on this book was:
- ◯ Excellent
- ◯ Satisfactory
- ◯ Needs Improvment

Something I would do differently next time is...

3 art vocabulary words I learned about with this book are:
1. _____
2. _____
3. _____

CREDITS

Edited by: KC
Cover & Artwork: a-studiocreatives.com

www.ingramcontent.com/pod-product-compliance
Lightning Source LLC
Chambersburg PA
CBHW062315220526
45479CB00004B/1175